ART to Start DOODLING

A SKETCHBOOK

Dawn DeVries Sokol

ABRAMS NOTERIE, NEW YORK

ISBN 978-1-4197-2716-0

Printed and bound in China
10 9 8 7 6 5 4 3 2 1

Abrams Noterie products are available at special discounts when purchased
in quantity for premiums and promotions as well as fundraising or educational
use. Special editions can also be created to specification. For details, contact
specialsales@abramsbooks.com or the address below.

ABRAMS The Art of Books
abramsbooks.com

115 West 18th Street
New York, NY, 10011
www.abramsbooks.com

if Found,

PLEASE RETURN TO:

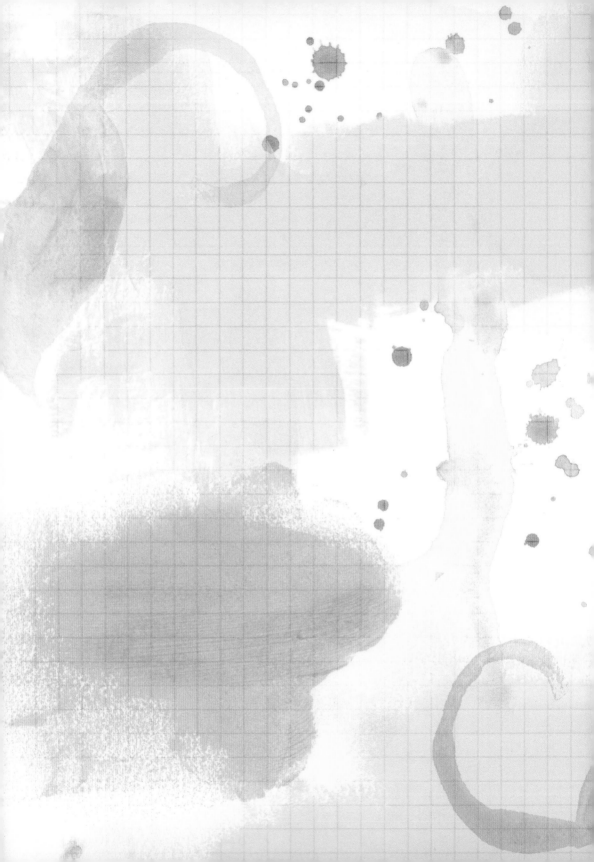

iNTRODUCTiON:

A blank page can feel energizing and exciting, full of infinite possibilities and opportunities to start fresh. But sometimes a blank page leaves us feeling stumped. All that potential can be intimidating and your mind can go just as blank as the page before you. How do you figure out where to begin?

Occasionally, we just need a little push, a little spark to get our creative fires going. This sketchbook supplies artful backgrounds to get you started. From vintage papers to soft watercolor washes to boldly vibrant brushstrokes, there is a background for every mood. Some pages have doodles already in place if you're really feeling stuck, and there are words of encouragement from great artists sprinkled throughout the book. Doodle whatever comes to mind and see where your imagination takes you. Turn paint daubs into paisleys, paper textures into geometric patterns, watercolor washes into dreamy landscapes, and more.

Use this sketchbook as a place to test out techniques, try new approaches, and dig deeper into your ideas. Experiment with pens, pencils, paint, and even bits of collage. You'll learn to trust your artistic impulses and find your creative voice along the way.

Explore, experiment, practice, play, and most importantly, HAVE FUN!

alárguese o acórtese aquí
allongez ou raccourcissez ici
lengthen or shorten he

NO GREAT ARTIST EVER

sees things

AS THEY REALLY ARE.
IF HE DID, HE WOULD

*cease to be
an artist.*

— Oscar Wilde

if YOU can
dREAM it,
you
can do iT.
~WALT DISNEY

Memoranda

Memoranda

KEEP
calm
~AND~
DOODLE
ON!

2
24
7
8
9
10
11
12
13

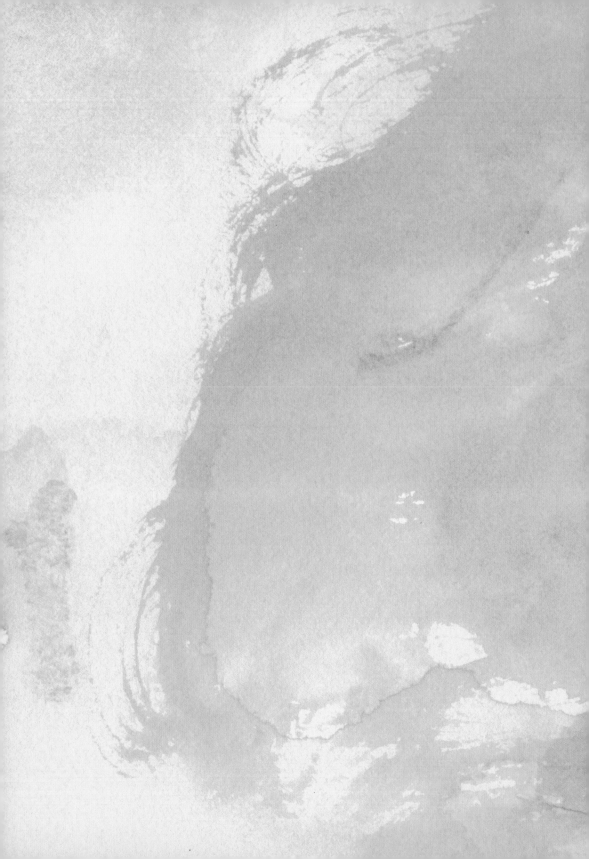

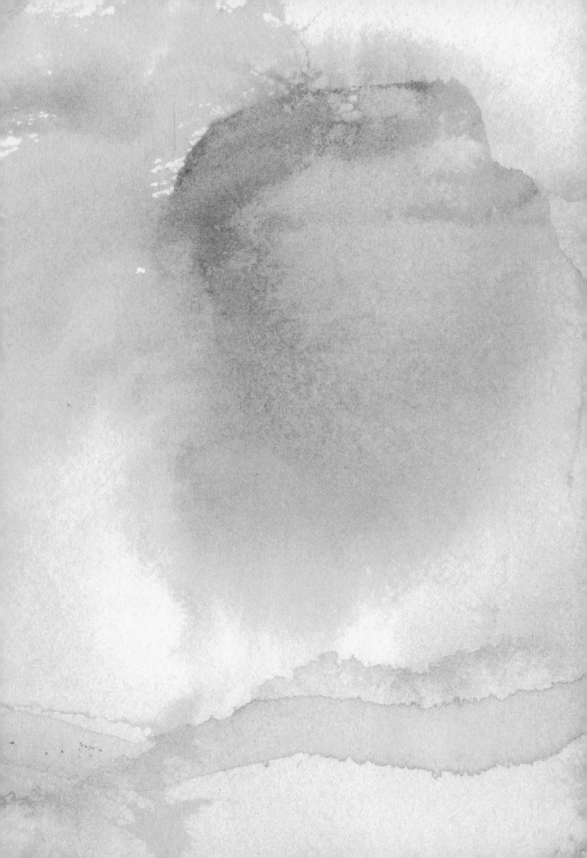

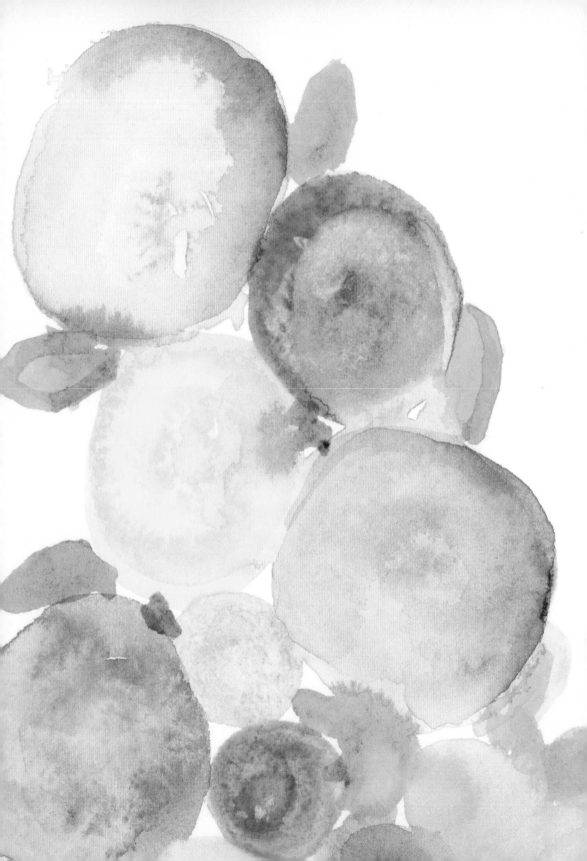

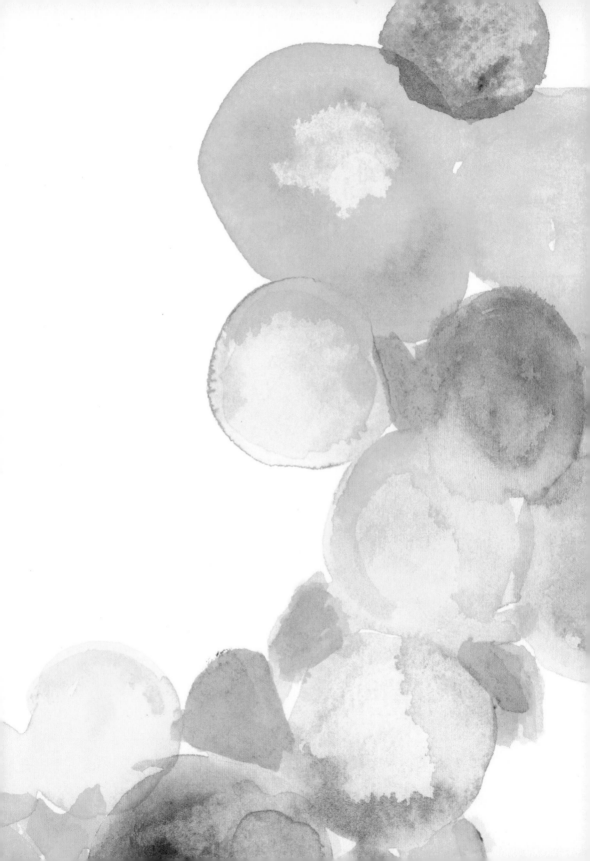

What art offers
is SPACE — A CERTAIN
breathing room
FOR THE SPIRIT.

— john Updike

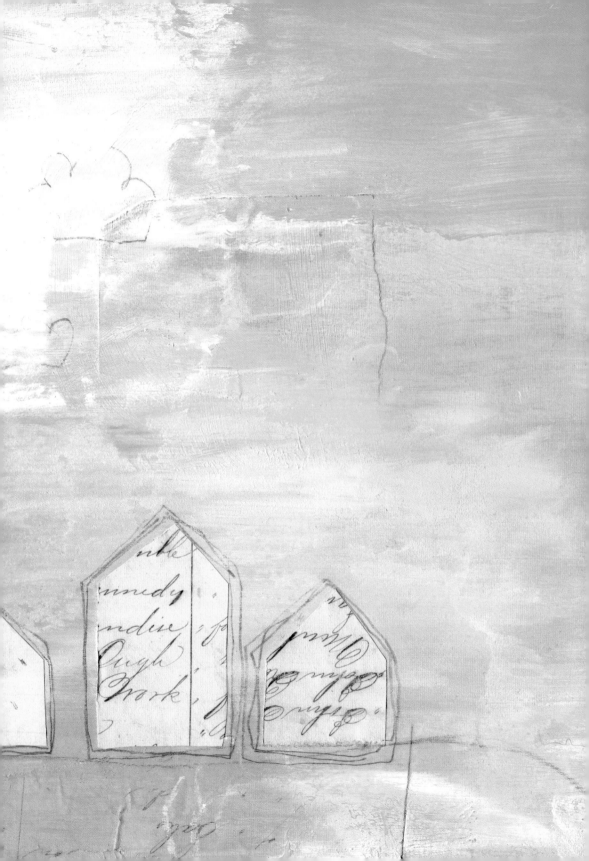

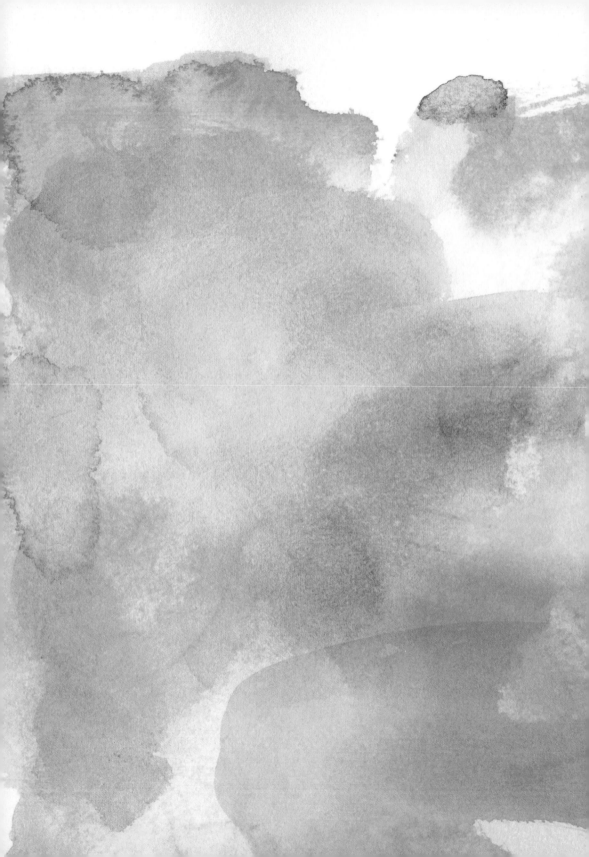

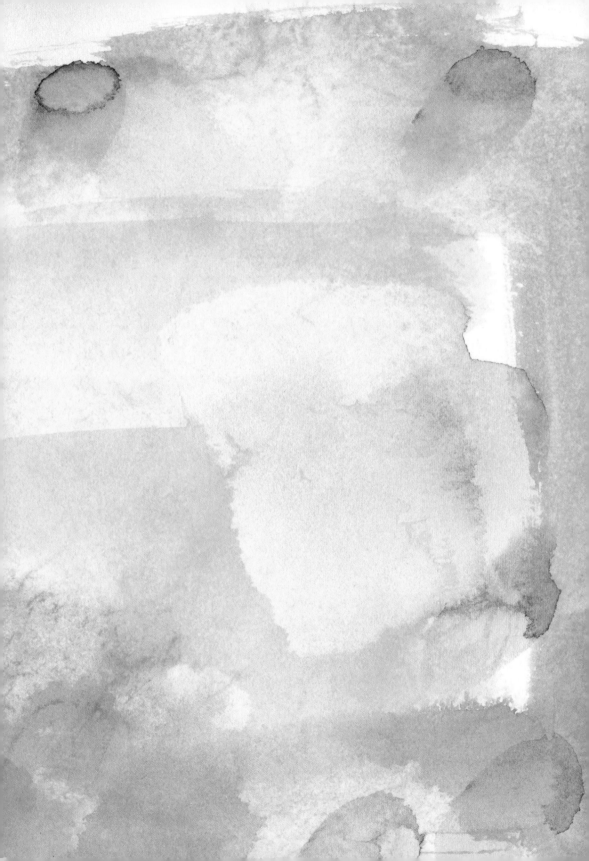

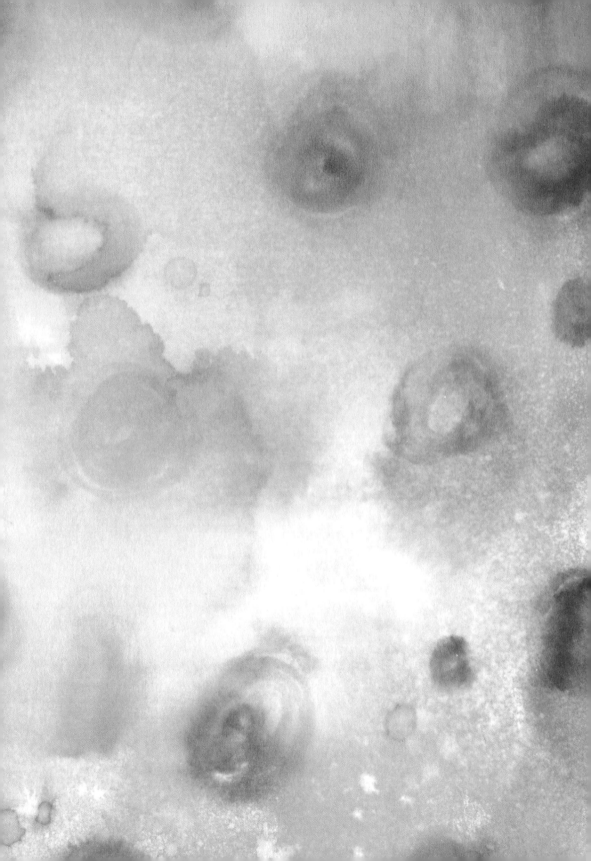

ARTISTS WHO SEEK *perfection* IN EVERYTHING ARE THOSE WHO CANNOT *attain* it in *anything.*

~Gustave Flaubert

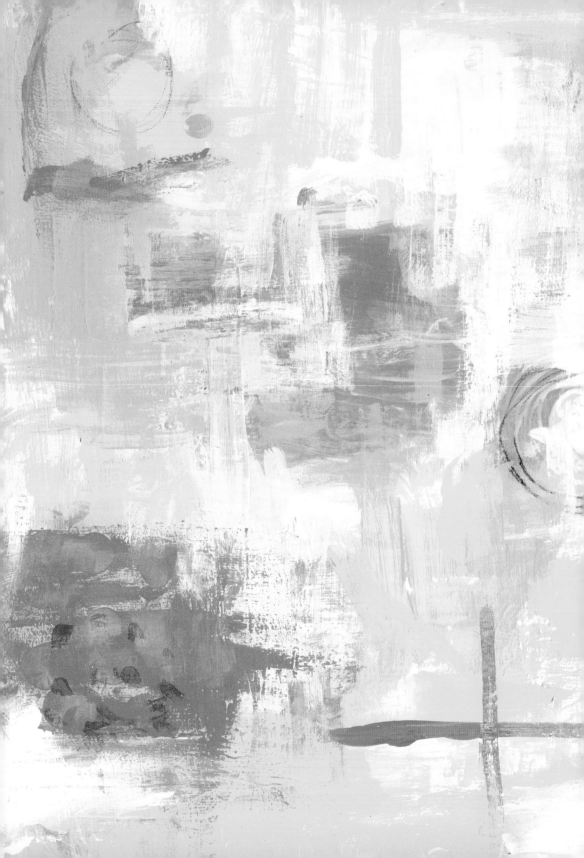

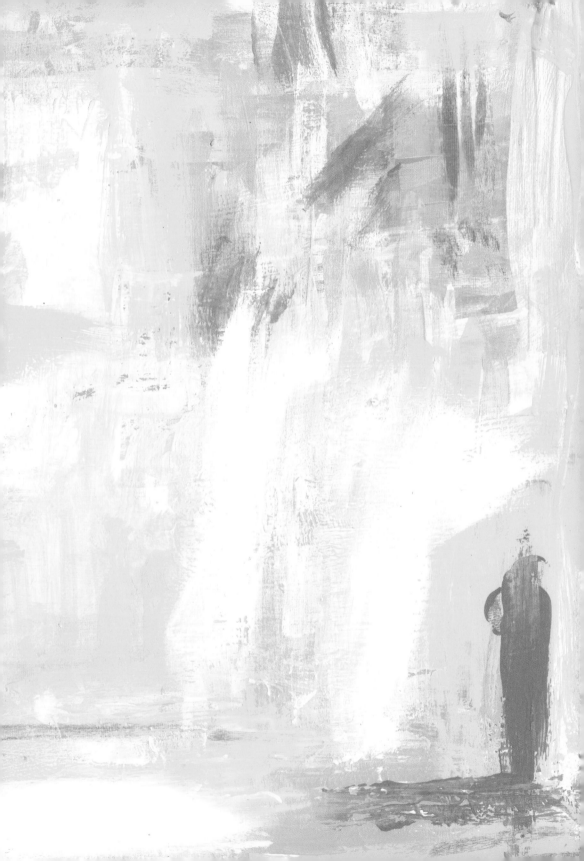

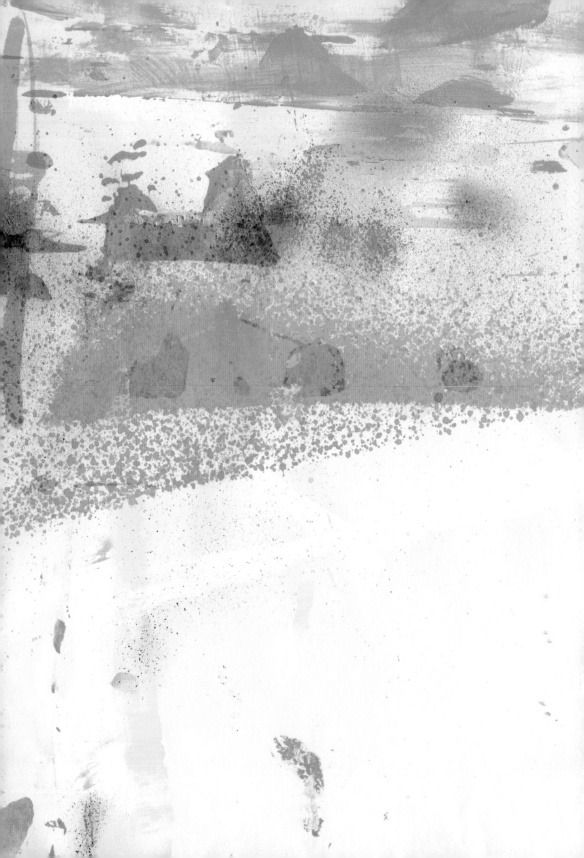

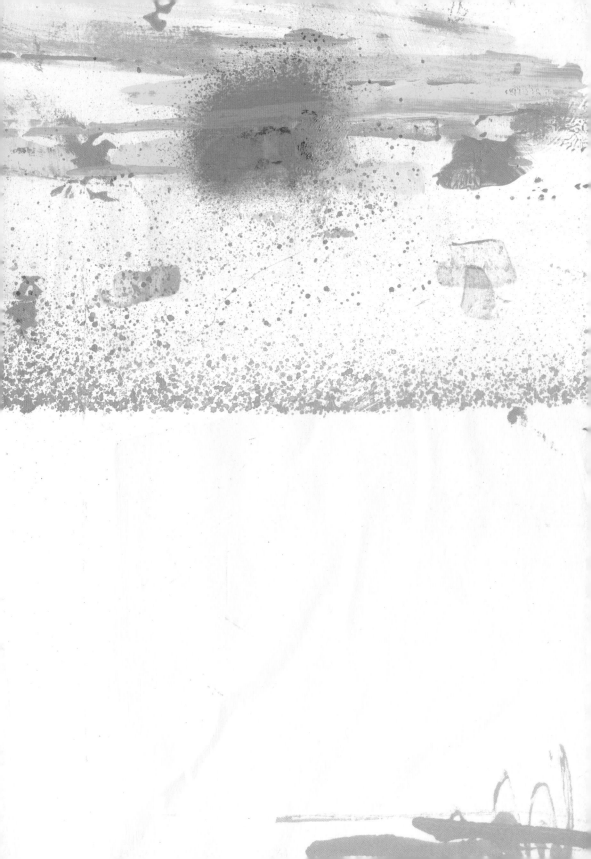

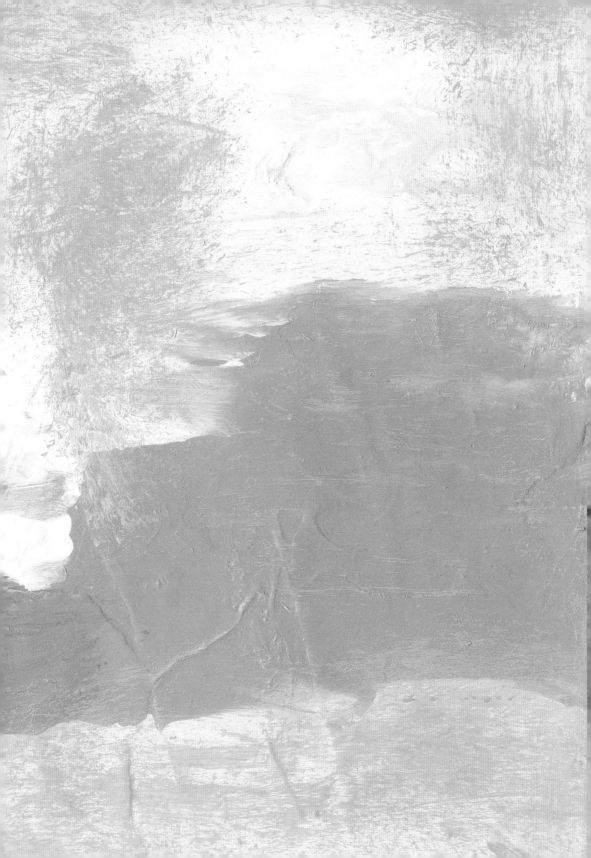

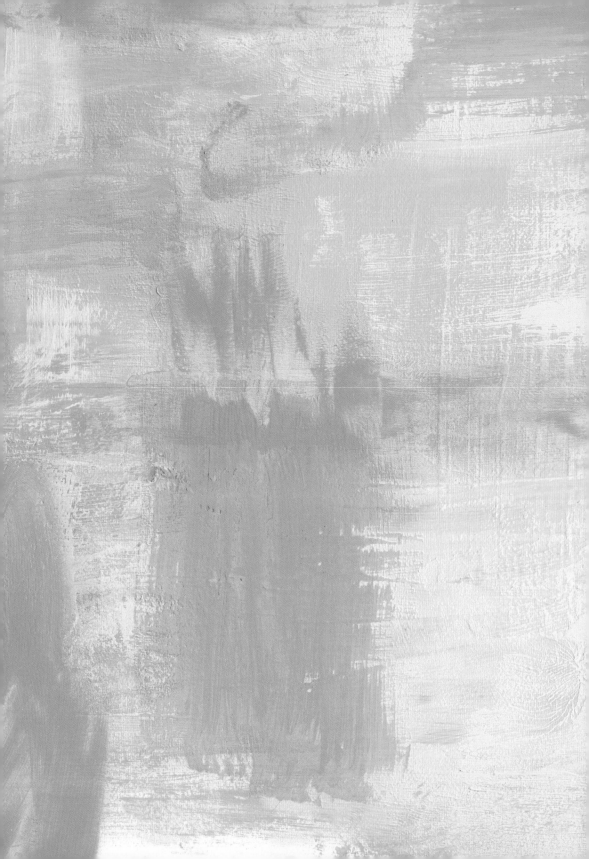

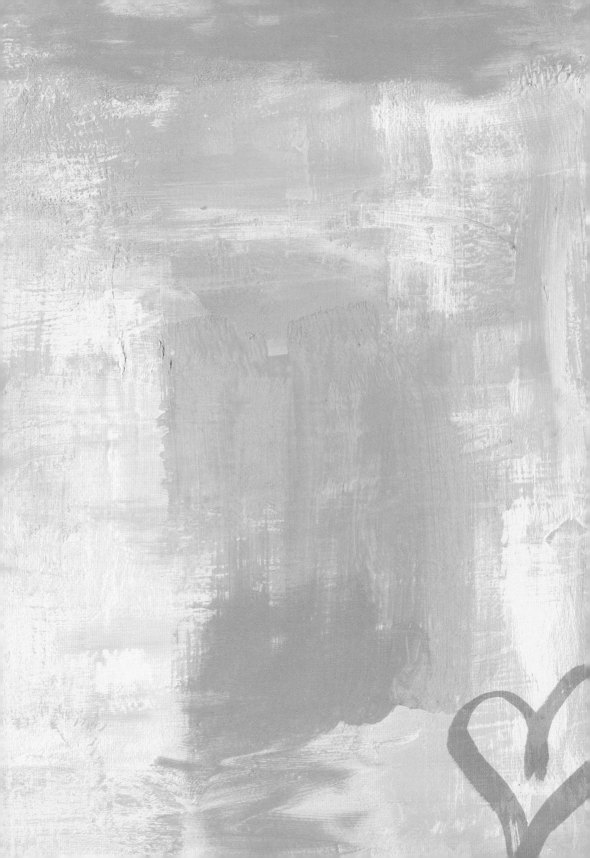

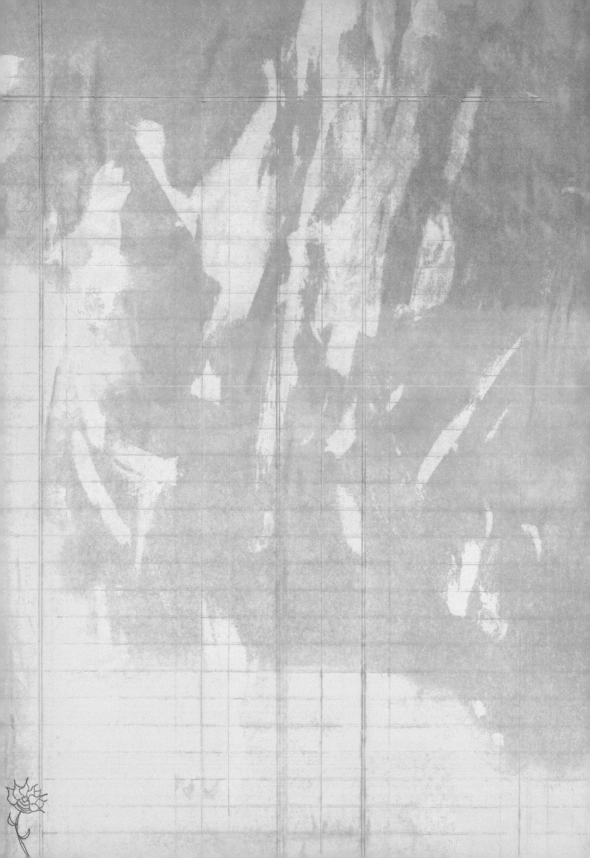

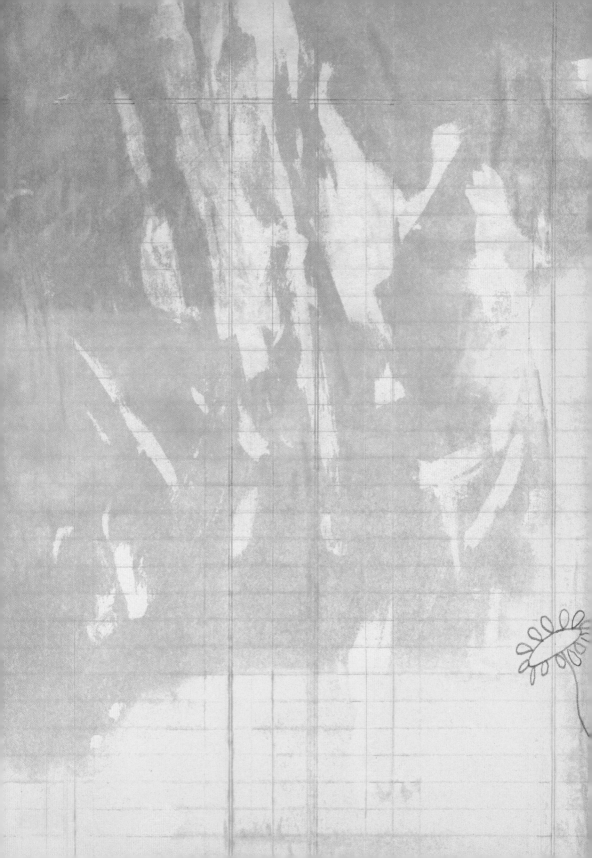

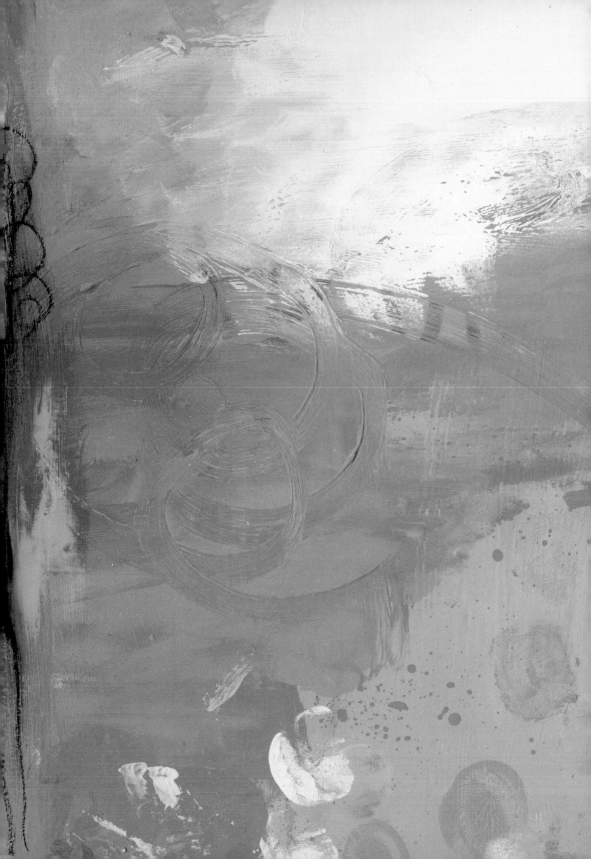

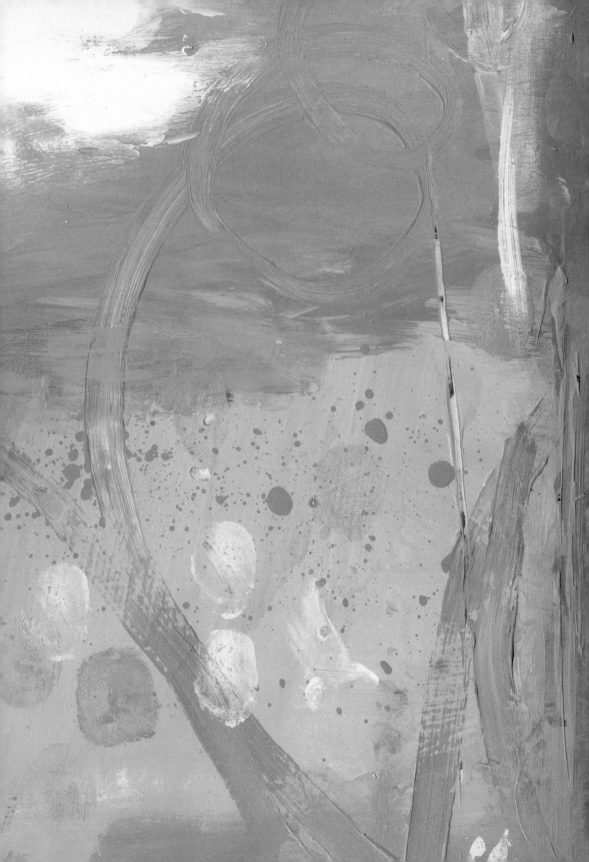

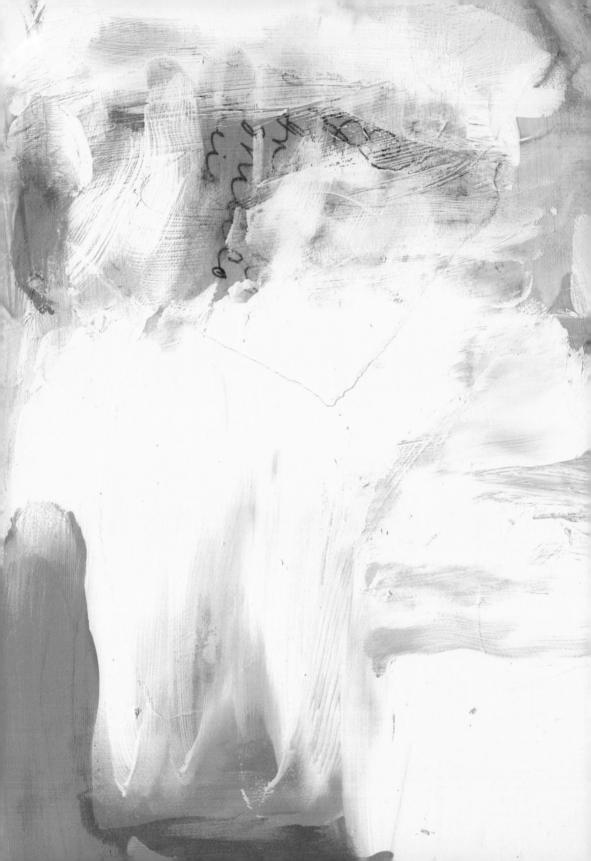

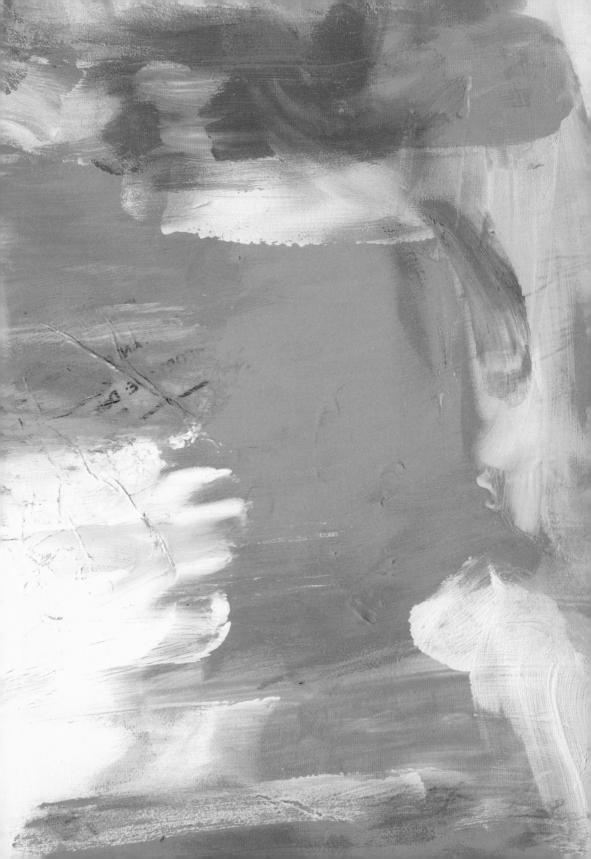

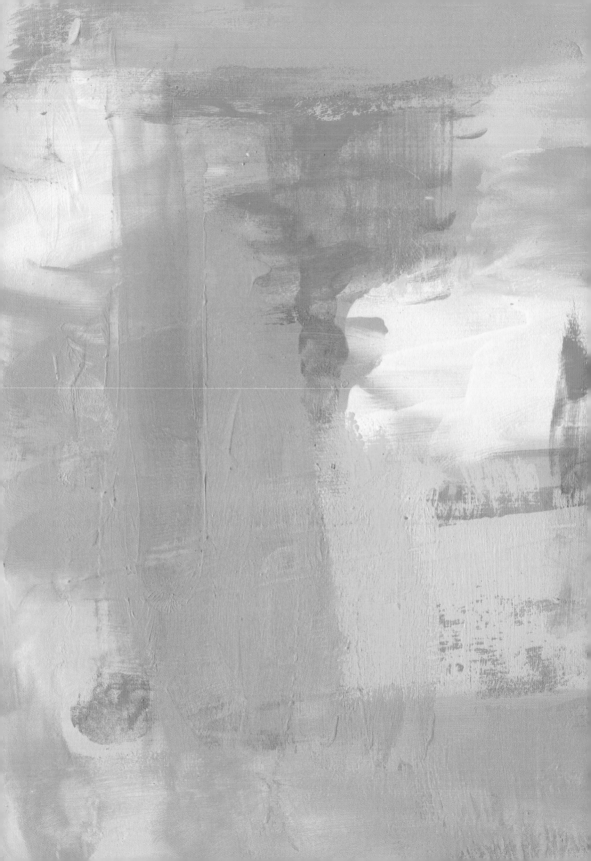

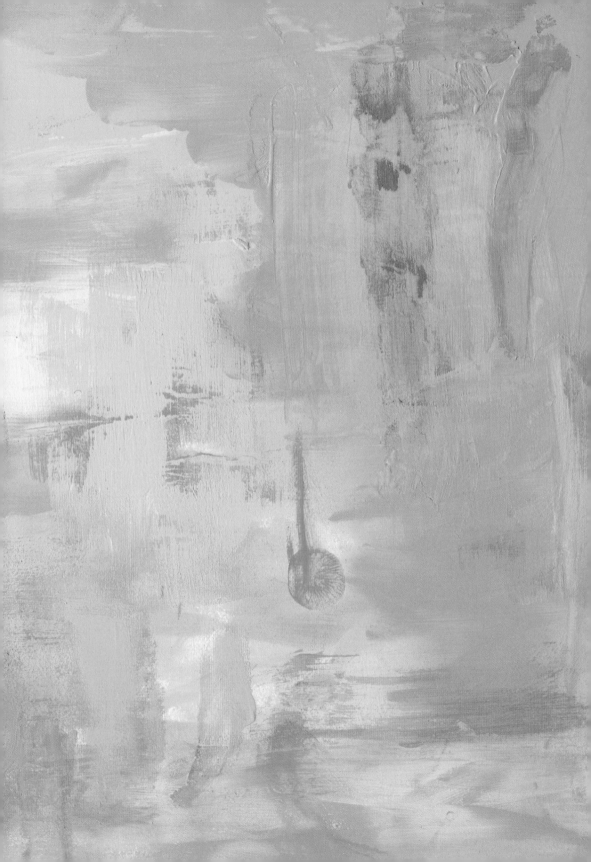

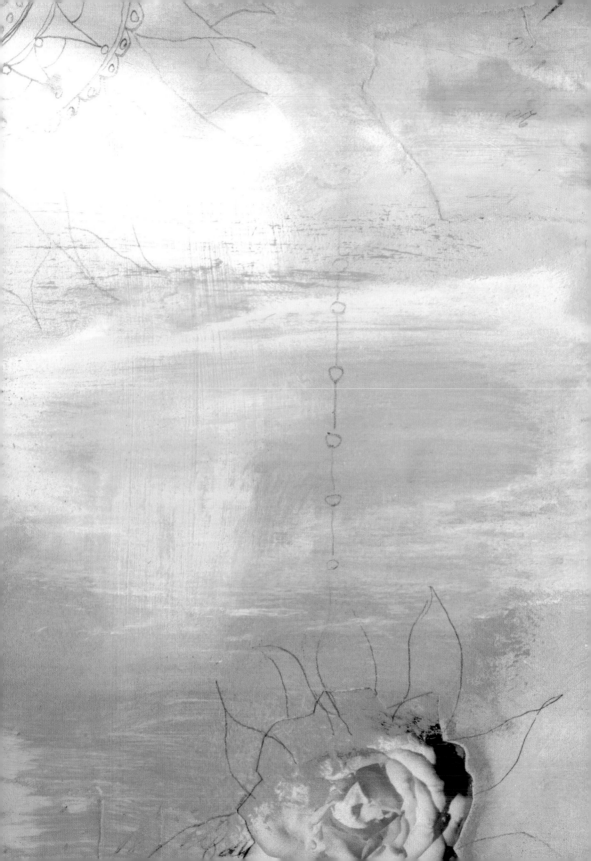

Art ENABLES US to
find ourselves
AND LOSE OURSELVES
AT THE SAME *time.*
~Thomas Merton

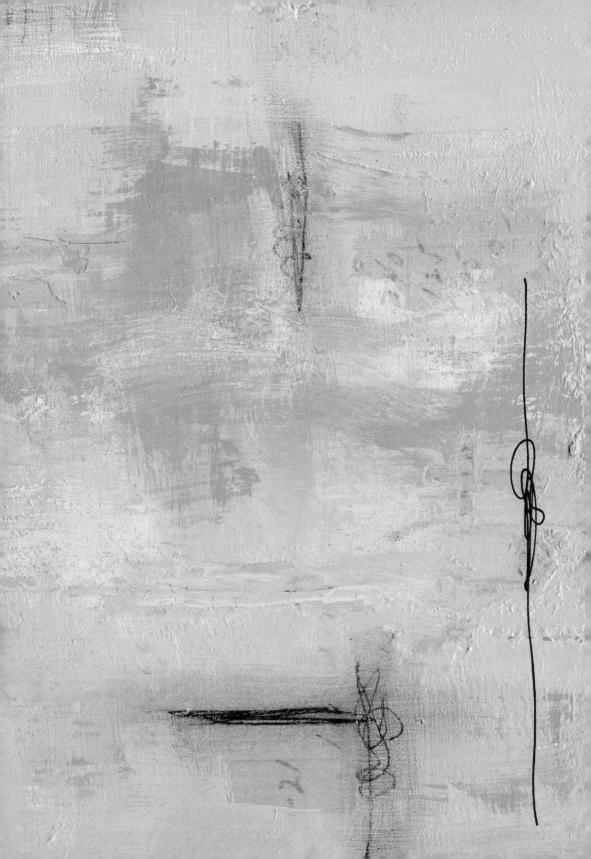

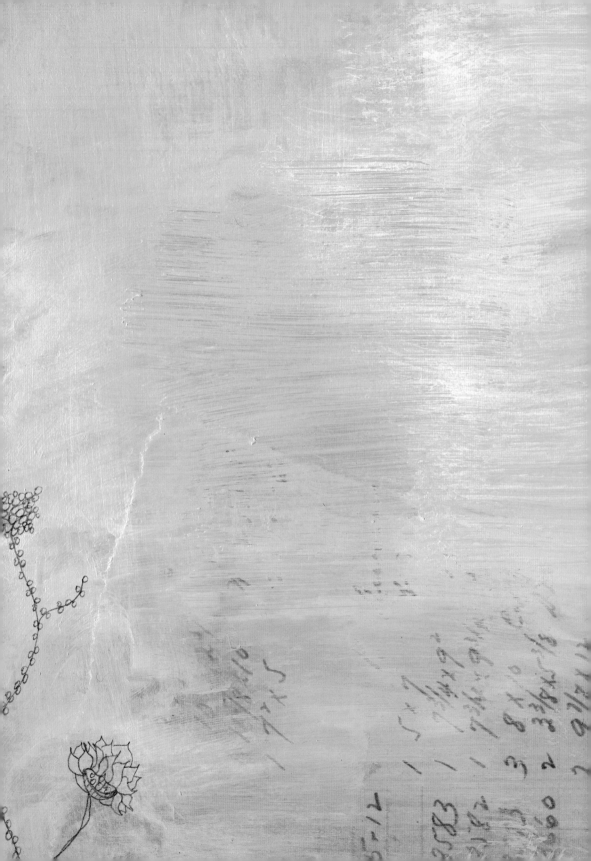

cette ligne sur la pliure du t
la línea sobre el doblez de l
fold of fabric

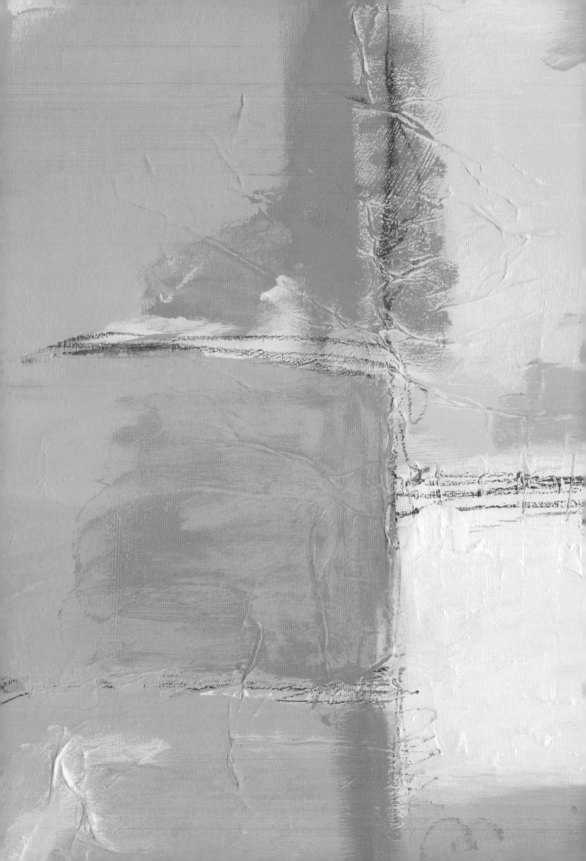

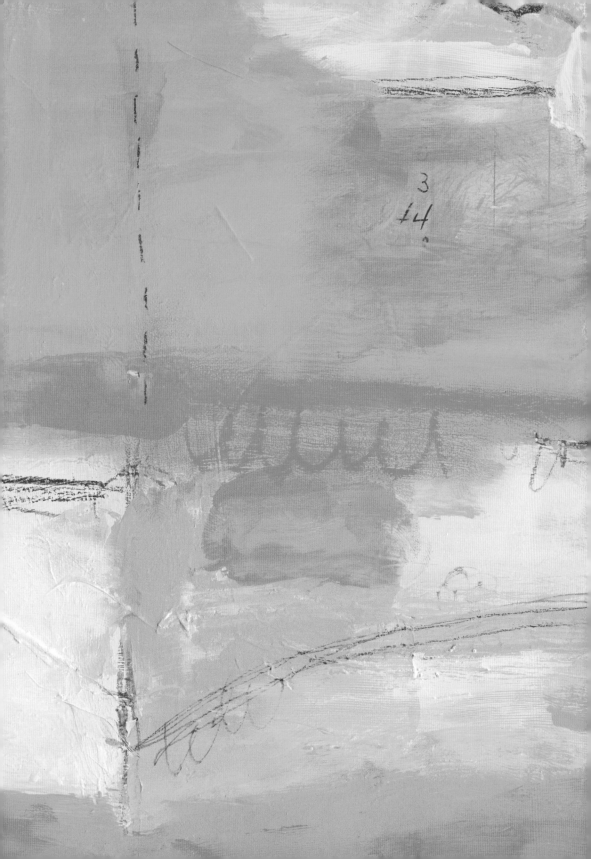

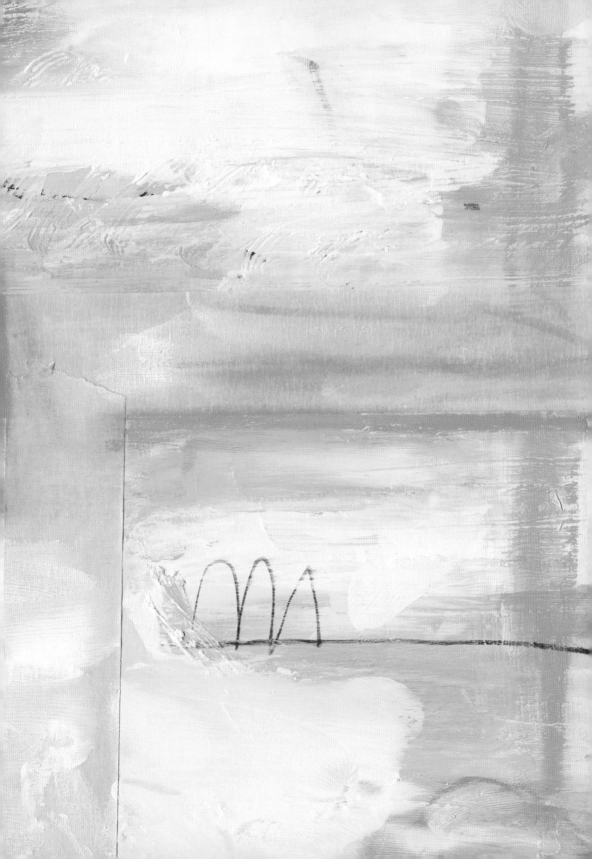

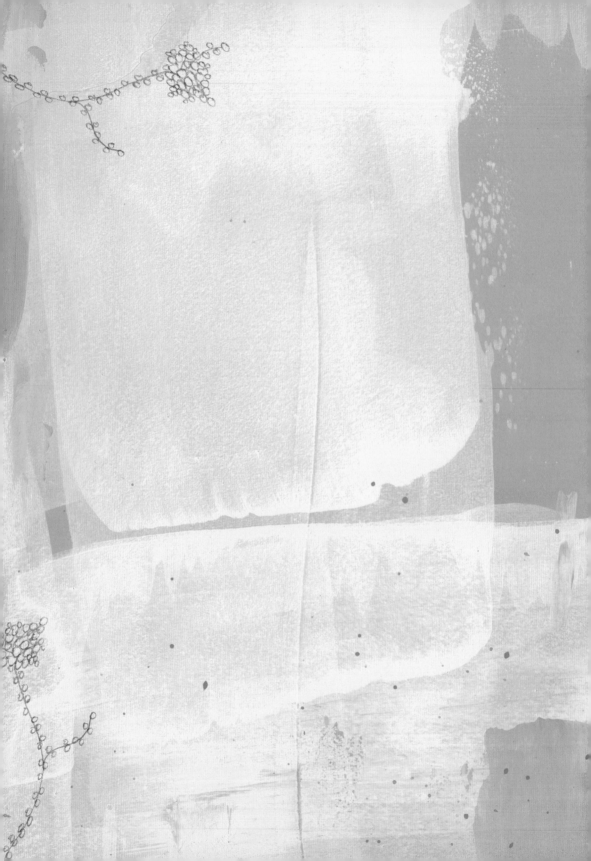

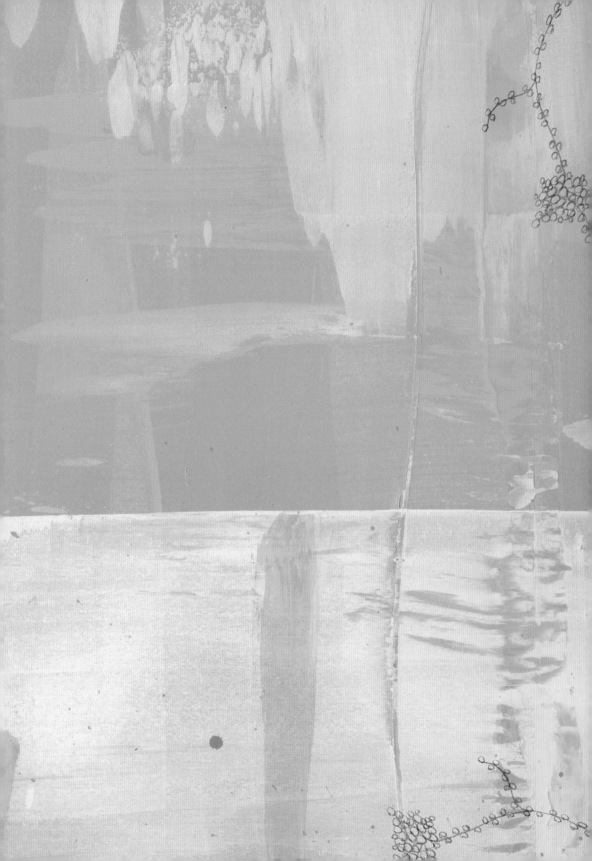